G000150913

To:

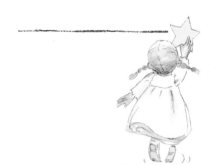

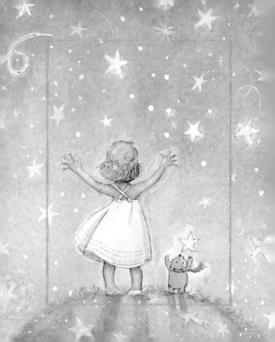

Magic Little Moments

Illustrated by Becky Kelly

Written by Patrick Regan

**Andrews McMeel
Publishing**

Kansas City

www.andrewsmcmeel.com
www.beckykelly.com

10 9 8 7 6 5

ISBN-13: 978-0-7407-2354-4
ISBN-10: 0-7407-2354-5

Edited by Jean Lowe
Designed by Becky Kanning
Production by Elizabeth Nuelle

Magic
Little Moments

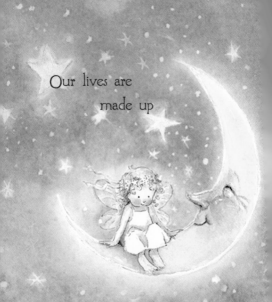

Our lives are
made up

of magic little

moments . . .

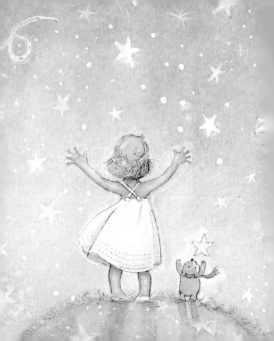

. . . which arrive

unexpectedly.

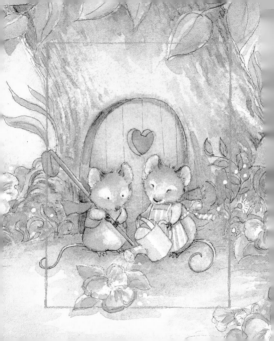

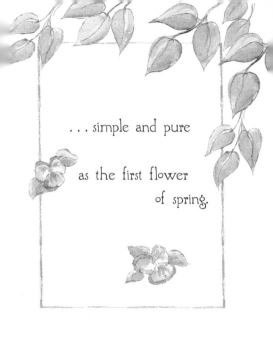

. . . simple and pure

as the first flower
of spring.

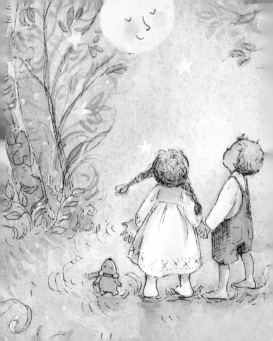

Like walking

in the woods

as evening falls . . .

Reading
a favorite book

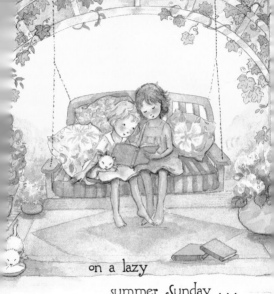

on a lazy

summer Sunday . . .

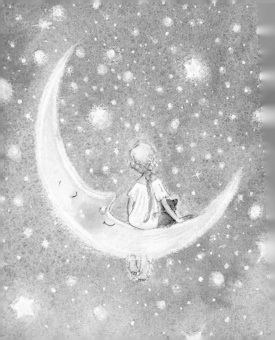

Wishing on the
same
shining star

with someone
you love . . .

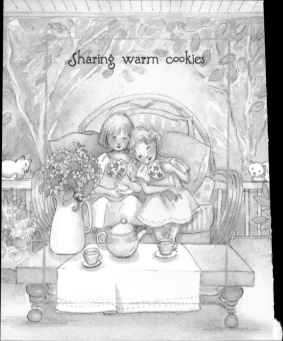

Sharing warm cookies

and cold milk

with a child—

or hot tea and
quiet conversation

with a dear
old friend.

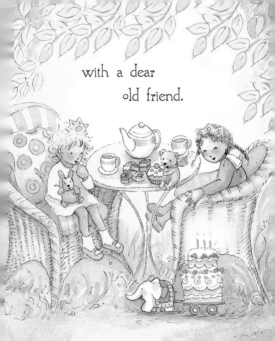

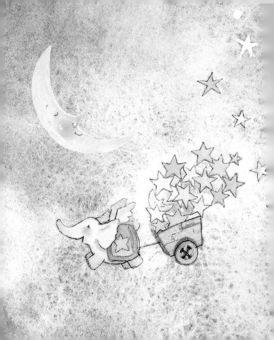

These
little moments
arrive

without
great fanfare . . .

. . . or a trumpet's blare . . .

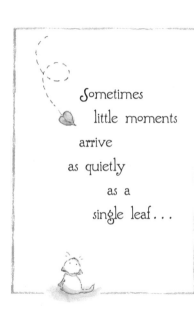

Sometimes
little moments
arrive
as quietly
as a
single leaf...

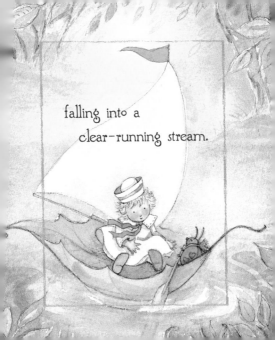

falling into a
clear-running stream.

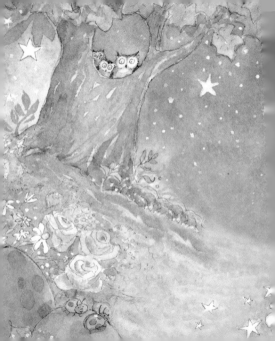

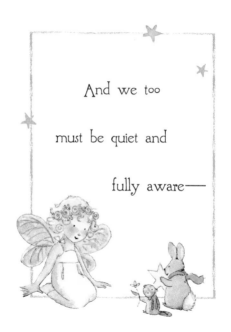

And we too

must be quiet and

fully aware—

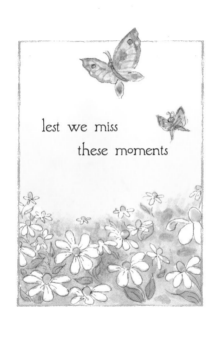

lest we miss
these moments

and the magic
they bring.

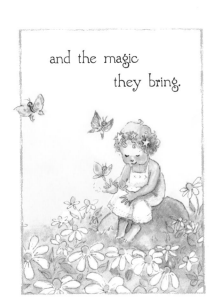

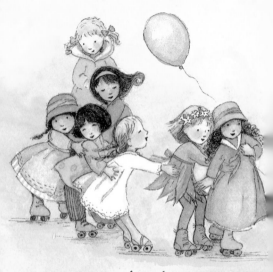

So revel in the joy

of celebrating life,

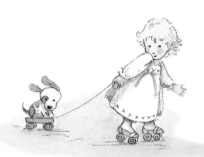

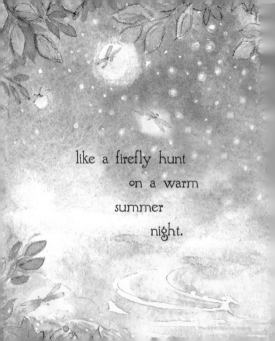

like a firefly hunt

on a warm

summer

night.

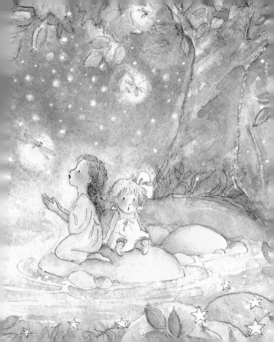

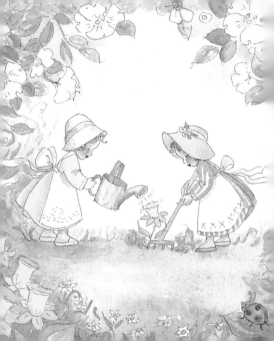

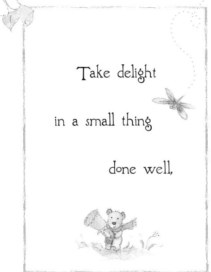

Take delight

in a small thing

done well,

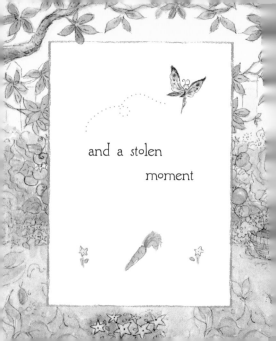

and a stolen

moment

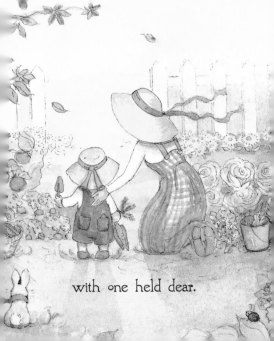

with one held dear.

Don't overlook
these simple
joys . . .

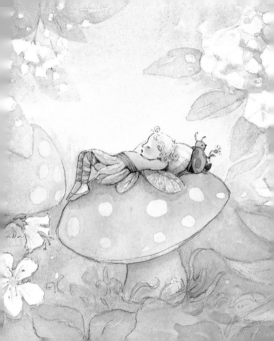

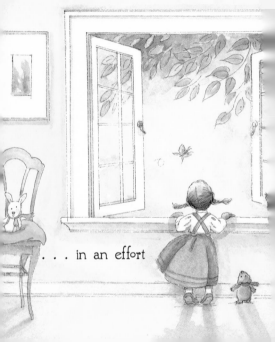

. . . in an effort

to see what lies ahead.

Celebrate them
with all
your heart . . .

For in these

magic little

moments . . .

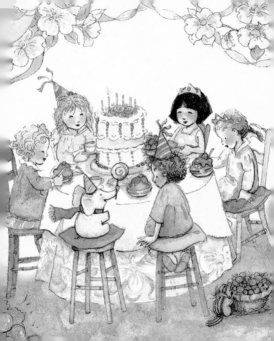

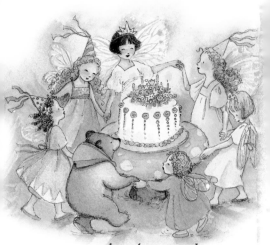

. . . lies the very best
of life.